T0130426

RILEY OUR LITTLE BEAR DOG

Bruce Connolly

AuthorHouse™
1663 Liberty Drive
Bloomington, IN 47403
www.authorhouse.com
Phone: 833-262-8899

Because of the dynamic nature of the Internet, any web addresses or links contained in this book may have changed since publication and may no longer be valid. The views expressed in this work are solely those of the author and do not necessarily reflect the views of the publisher, and the publisher hereby disclaims any responsibility for them.

Any people depicted in stock imagery provided by Getty Images are models, and such images are being used for illustrative purposes only.
Certain stock imagery © Getty Images.

This book is printed on acid-free paper.

ISBN: 978-1-6655-4854-0
ISBN: 978-1-6655-4855-7

Library of Congress Control Number: 2022900300

Print information available on the last page.

Published by AuthorHouse 07/06/2022

authorHOUSE®

BY BRUCE CONNOLLY

FOR YOUNG
CHILDREN

AND
CHILDREN LIKE

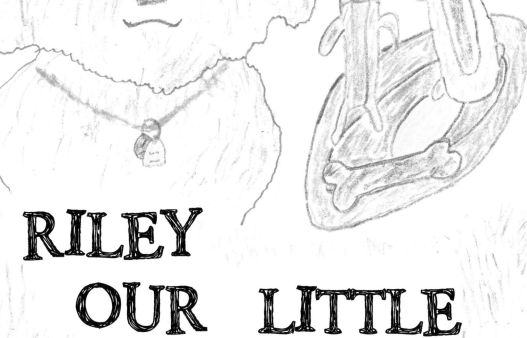

RILEY
OUR LITTLE
BEAR DOG

A CAVAPOO
KING CHARLES CAVALIER AND
POODLE BREED

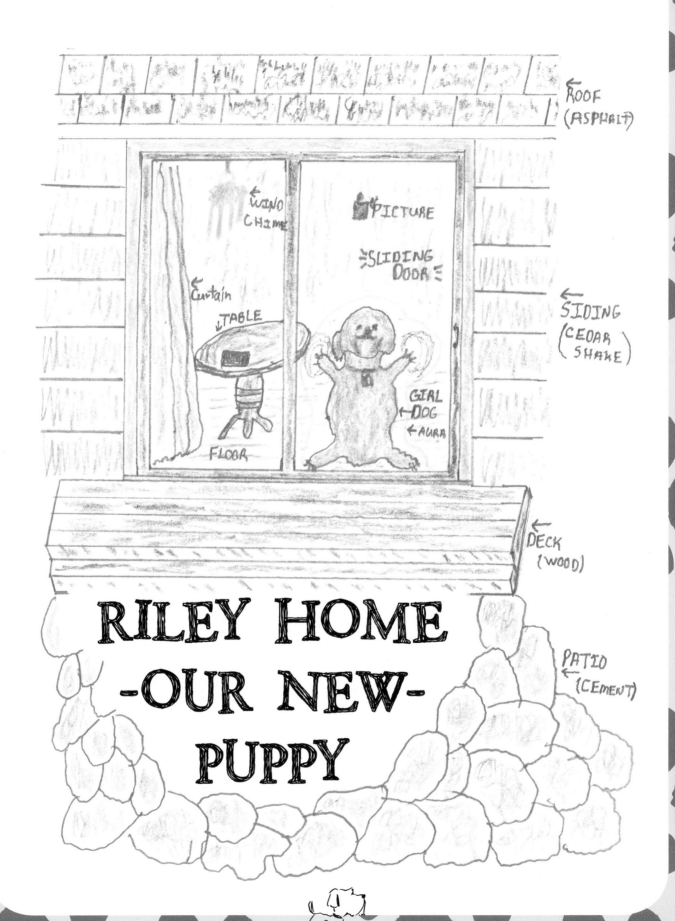

ROOF
(ASPHALT)

WIND
CHIME

PICTURE

SLIDING
DOOR

Curtain

TABLE

SIDING
(CEDAR
SHAKE)

GIRL
DOG
AURA

FLOOR

DECK
(WOOD)

RILEY HOME
-OUR NEW-
PUPPY

PATIO
(CEMENT)

BIRDS LOOK DOWN FROM A TREE TOP

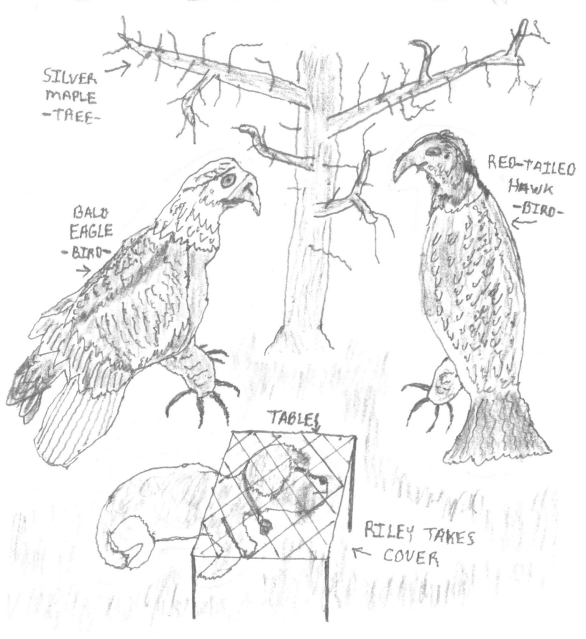

SILVER MAPLE -TREE-

RED-TAILED HAWK -BIRD-

BALD EAGLE -BIRD-

TABLE

RILEY TAKES COVER

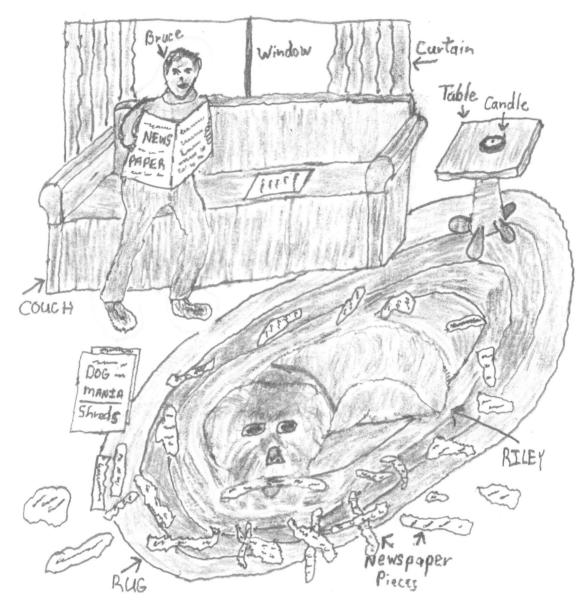

DAD AND RILEY READ THE NEWSPAPER

RILEY PEEKS INTO THE - BATHROOM -

NO PRIVACY

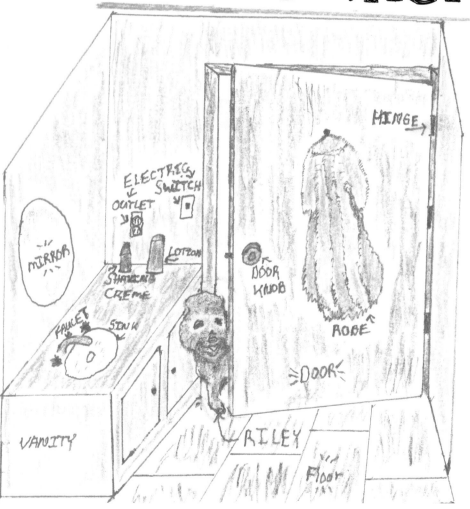

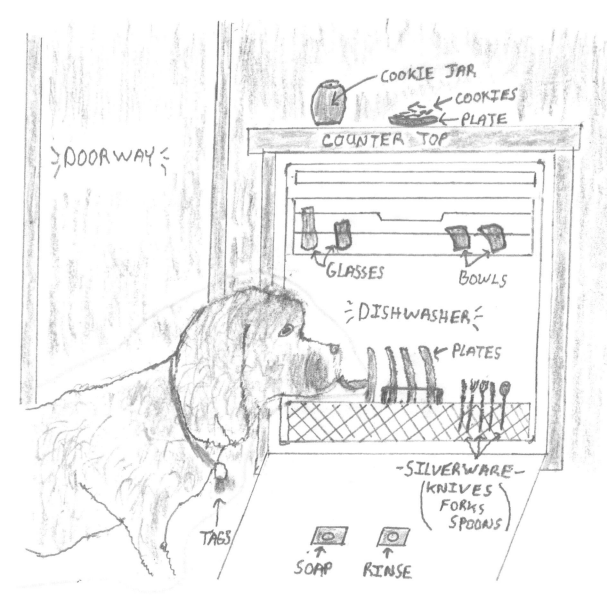

COOKIE JAR
COOKIES
PLATE
COUNTER TOP
DOORWAY
GLASSES
BOWLS
DISHWASHER
PLATES
-SILVERWARE-
(KNIVES
FORKS
SPOONS)
TAGS
SOAP RINSE

RILEY CLEANS THE DISHES

RILEY CHASES A MOUSE OUT OF THE HOUSE

← CHEESE

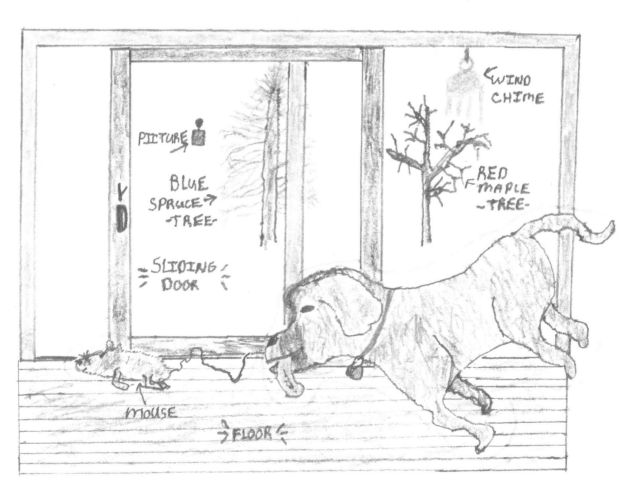

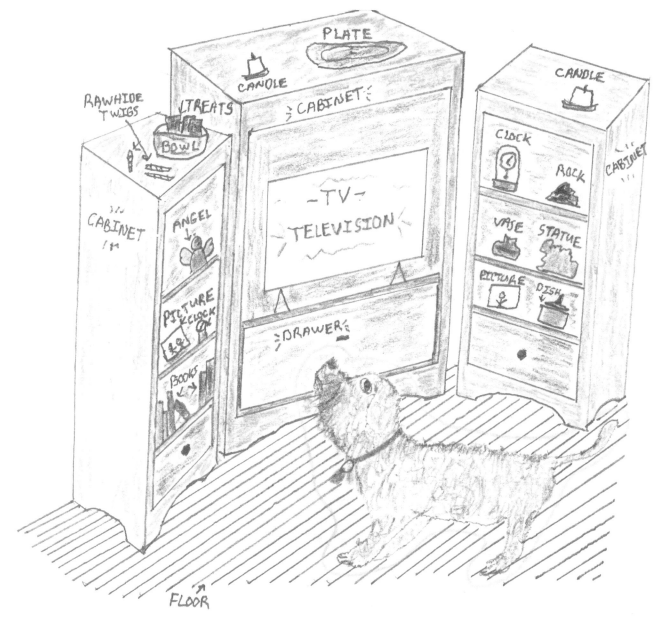

PLATE

CANDLE

CABINET

RAWHIDE TWIGS

TREATS

BOWL

CANDLE

CLOCK

ROCK

CABINET

CABINET

ANGEL

VASE

STATUE

- TV -
TELEVISION

PICTURE
CLOCK

PICTURE

DISH

BOOKS

DRAWER

FLOOR

RILEY IN
A TREAT
STARE

RILEY TAKES DAD FOR A WALK

PAW PRINTS

FOOTPRINTS

POND

FOUNTAIN

Bruce →

PATH

GRASS

MAIL PERSON THIS IS
DIFFERENT?

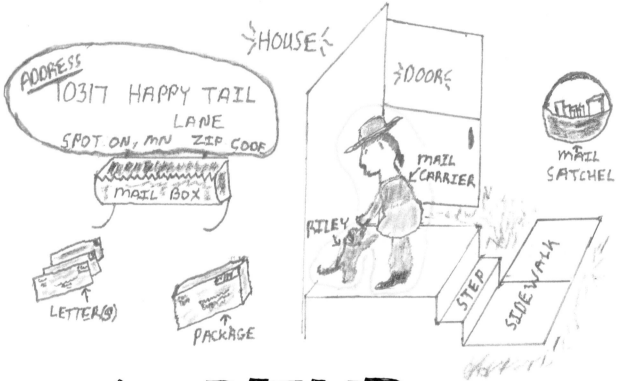

A FRIEND

A BABY SQUIRREL FALLS OUT OF ITS NEST

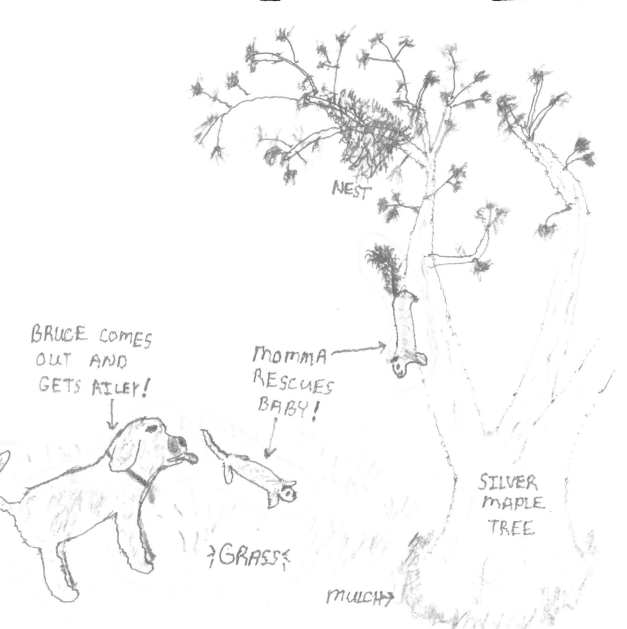

←SEEDS→

NEST

BRUCE COMES
OUT AND
GETS RILEY!

MOMMA
RESCUES
BABY!

SILVER
MAPLE
TREE

→GRASS←

MULCH→

RILEY AT THE GROOMER

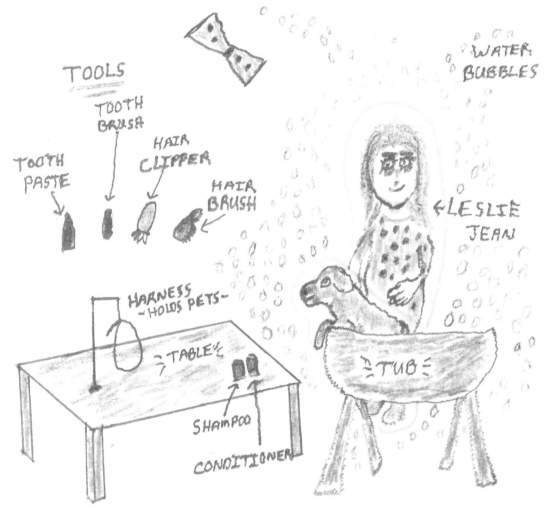

BOWS

TOOLS

TOOTH BRUSH

TOOTH PASTE

HAIR CLIPPER

HAIR BRUSH

WATER BUBBLES

←LESLIE JEAN

HARNESS ~HOLDS PETS~

TABLE

SHAMPOO

CONDITIONER

TUB

PRETTY GIRL

RILEY AT THE VETERINARIAN

SHORT NAME →ANIMAL DOCTOR←

CHECKS

TECHNICIAN ASSISTANT JULIA →

RACHEL, DVM

STETHOSCOPE (LISTENING) DEVICE

HEART

LUNGS

STOMACH

NOSE
MOUTH
TEETH
TOUNGUE

PAWS
NAILS
PADS

HEALTHY GIRL!

UPDATES SHOTS
UPDATES MEDICATIONS
PROTECT AGAINST
- TICS
- HEARTWORM
- MORE

A COMPLETE CHECK

13

RILEY PLAYS BIG DOG LITTLE DOG

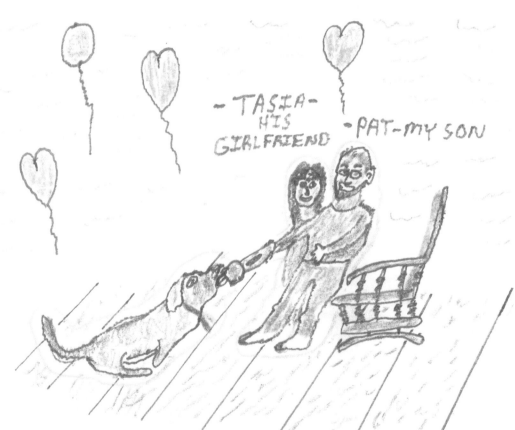

-TASIA- HIS GIRLFRIEND

-PAT- MY SON

RILEY WINS!

14

RILEY AT HERBIES HOUSE

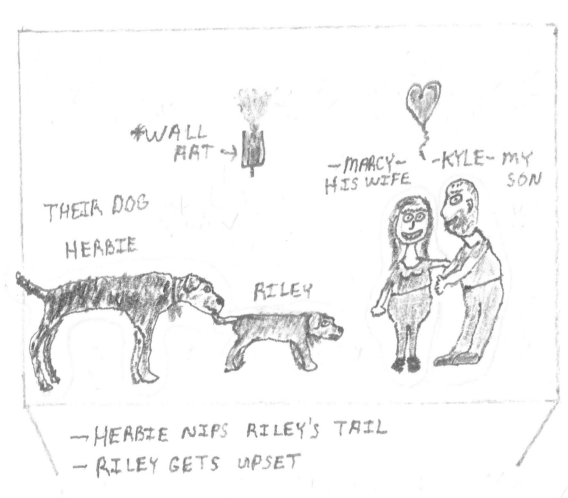

*WALL HAT →

THEIR DOG HERBIE

RILEY

—MARCY—
HIS WIFE

—KYLE— MY
SON

- HERBIE NIPS RILEY'S TAIL
- RILEY GETS UPSET

—HERBIE IS A GOLDENDOODLE—
A GOLDEN RETRIEVER AND POODLE
BREED — THEY CAN BE BLACK—

RILEY
AT THE
LAKE

DOCK

→BOARDS←

LELLYPADS

 WATER

SNAPPING
TURTLE

HANDLE

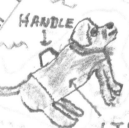

LIFE
JACKET

muskrat

→PATH←

⇒WEEDS⇐

RILEY ON THE PONTOON BOAT

SUN

CLOUDS

Jo Anne, Bruce's Wife

OUTBOARD MOTOR

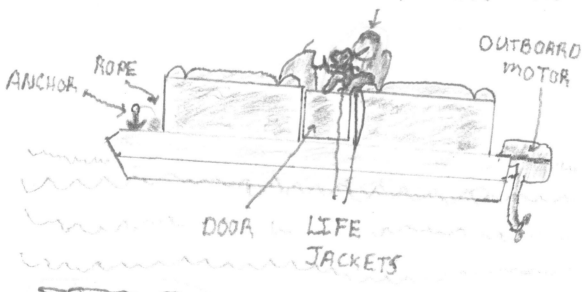

ANCHOR

ROPE

DOOR

LIFE JACKETS

NORTHERN PIKE~FISH

RILEY EATS HER SNACKS

Yum! Yum! Yum! Yum! Yum! Yum!

PEAS

BROCOLLI

CARROTS

WE USUALLY COOK THESE

FRENCH CUT BEANS

HEALTHY

IMPORTANT CUT SMALL!

CAULIFLOWER ~ RAW OR COOKED

FAVORITE

RILEY HAS MY BACK!
I HAVE HERS!

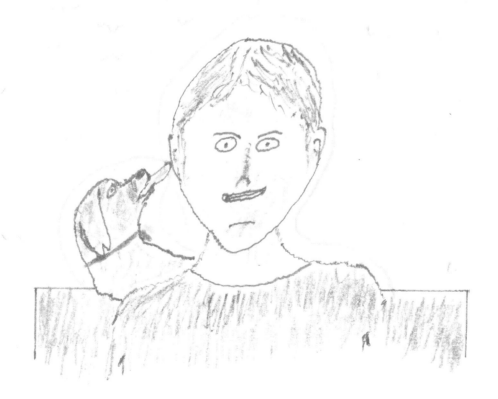

-THE END-

-SYMBOL-
-ARCHANGEL-

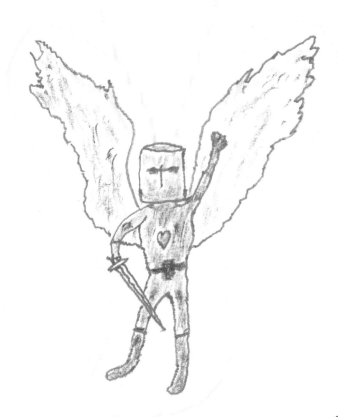

-OF LIGHT-

SIGN

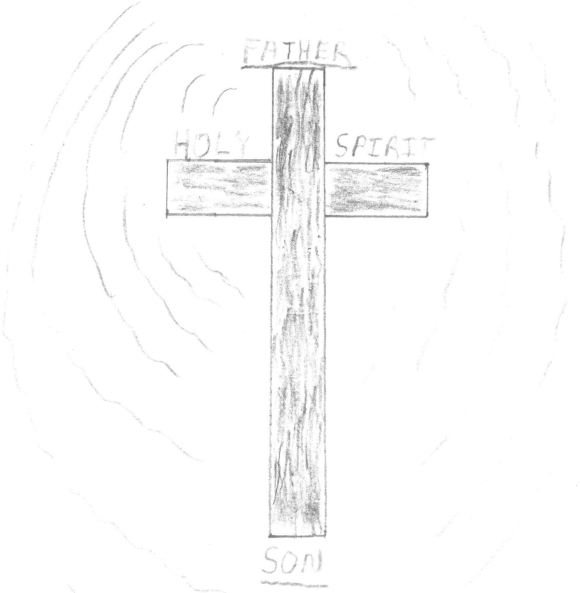

COLOR LEGEND

—— RED

GOLDEN YELLOW

YELLOW

—— RED ORANGE

PEACH

GRAY

—— BROWN

LIGHT BROWN

MAHOGANY

MAGENTA

PINK

TAN

—— BLUE

—— SKY BLUE

LIGHT BLUE

VIOLET

ORANGE

YELLOW ORANGE

GREEN

YELLOW GREEN

JADE GREEN

AQUA GREEN

—— BLACK

WHITE

CRAYOLA COLORED PENCILS

22

FINAL PAGE

Names:

TONGUE
(DOG
KISS)
LICKS!

* * *
The
best of wishes
to
you!
* * *

HIGH
PAW!!!

Your Friend Bruce And Riley!

About the Author

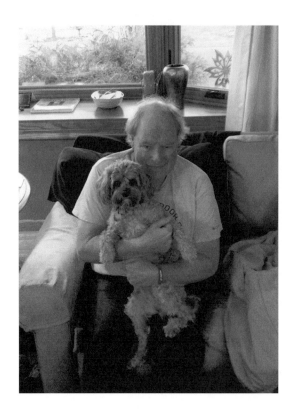

Bruce Connolly and my wife Jo Anne are from Bloomington, MN. We purchased Riley from Jo Anne's brother Jeff and his wife Chris who raise puppy's at their home near Elk River, MN. She was such a little peanut to begin with a very nice pleasant personality and just a shear joy to be around. She was a bit of a challenge to potty train to begin with but after a few months she caught on perfectly. She is a great sidekick to have with us.

We all enjoy Riley in the house playing, naps and having treats. We also head in the back yard and play with her and her toys and have fires and go out for walks. The stories abound about Riley's daily activities.

We take trips to our Cabin on the Flambaeu Flowage near the Village of Tony, Wi where we relax and enjoy the water and lake activities, such as wading, swimming and boating. Please enjoy the Riley Our Little Bear Dog book through these life adventures!

Printed in the United States
by Baker & Taylor Publisher Services